RIJKSMUSEUM AMSTERDAM

HIGHLIGHTS OF THE COLLECTION

MARKO KASSENAAR

'The country's divine sons, united in this Pantheon'
(Excerpt from a poem celebrating the opening of the Rijksmuseum - 1885)

'A feel for beauty, a sense of time'
(Motto of the Rijksmuseum - 2013)

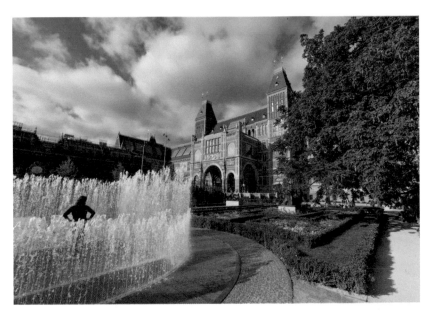

Rijksmuseum Amsterdam, photo by Evgeny Prokofyev

CONTENTS

INTRODUCTION

The Rijksmuseum (Dutch for 'National Museum') houses the biggest and most important art collection of the Netherlands. The cathedral-like building contains the works of the 17th-century Dutch Masters such as Rembrandt, Vermeer and Hals. The museum also boasts a world famous collection of Asian art, Dutch doll's houses and Meissen porcelain. In total, the Rijksmuseum guards over 1,1 million objects. The most famous and prestigious work of the Rijksmuseum collection is *The Night Watch* by Rembrandt van Rijn.

In the Rijksmuseum you literally walk through history. Every section of the museum is dedicated to a specific century. In each room, works of various art disciplines are exhibited together. This combination of paintings and objects lets you experience the atmosphere of different periods in time.

You can, for example, visit a 17th-century painting gallery or an 18th-century 'style room' decorated with tapestries and ornamental stucco. Medieval and Renaissance art is on display in the basement vaults.

The Rijksmuseum building is a work of art in itself. Architect Pierre Cuypers (1827 - 1921) designed it as a temple where the gods of Dutch

art would reside. The result looks like a mixture of a cathedral and a gigantic Amsterdam canal house.

During recent renovations, a spacious atrium was created in the inner courtyards of the building. In the atrium you can buy your tickets, visit the museum shop or relax in the cafeteria.

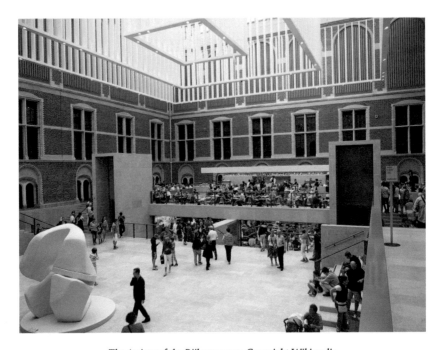

The Atrium of the Rijksmuseum, Copyright Wikimedia

TIP: RIJKS® is the Rijksmuseum's restaurant in the Philips Wing. This lively brasserie has been awarded a Michelin star and serves great food. The Rijksmuseum itself has a café (with lunch menu) and three espresso bars.

GALLERY OF HONOR AND 17TH-CENTURY ART

The main collection of the Rijksmuseum consists of paintings by the Dutch Masters of the 17th century such as Rembrandt, Vermeer and Hals. This period in history is known, both economically and artistically, as the Dutch Golden Age. The Netherlands were a world power with rulers spending lots of money on art and science. Besides paintings, there is a collection of silverware, furniture, earthenware and glass.

The 17th-century collection is exhibited in the Front Hall, the Gallery of Honor and the Rembrandt Hall. These rooms are located in the heart of the building on the first floor. More works are on display in the smaller rooms and corridors connecting these three areas.

The Front Hall is the area where Dutch art and history are glorified. Hand-painted decorations on the walls show the beauty and power of nature while tapestries tell stories of important events in Dutch history. The mosaic floor is full of symbols of the four seasons, the galaxy and the star signs. The stained-glass windows are portraits of great musicians, poets and philosophers. Because the decorations are so abundant, it has been decided not to display other objects in this hall.

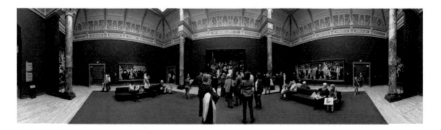

The Gallery of Honor, 2015, Copyright Creative Commons

The Gallery of Honor connecting the Front Hall to the Rembrandt Hall is the heart and soul of the museum. Here you will find the most famous paintings of the Netherlands. If you have limited time, you should definitely visit this gallery.

Designed like the nave of a cathedral, the gallery is a stretched walkway with rooms on either side that serve like little art chapels. Above the side rooms, mural decorations show the arts and crafts of the different provinces of the Netherlands.

The vaults are covered with plants, flowers and petals in paint and stone, while the pillars show various symbols of art and nature.

Apart from *The Night Watch*, the following picture is one of the most popular paintings in the gallery of honor: two lovers in a tender embrace, portrayed by Rembrandt. This painting is known as *The Jewish Bride* but it is probably a portrait of Isaac and Rebecca, taken from the Old Testament. Having to hide their love from others, they act as if they are brother and sister in daily life. When they believe themselves to be unobserved, they can show each other their affection.

Isaac presents his beloved with a golden necklace which he cautiously arranges on her shoulders and chest. While doing so, he slightly touches her left breast. This intimate gesture is answered by Rebecca who puts her fingertips on the back of his hand. Thus, Rembrandt masterfully creates an atmosphere of intimacy and tenderness.

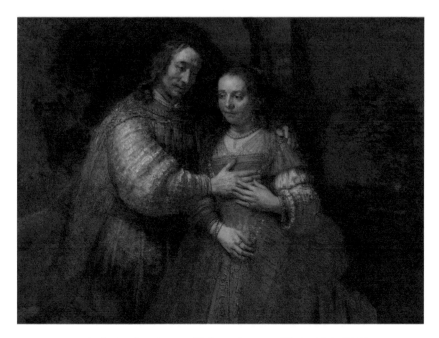

Portrait of a Couple as Isaac and Rebecca, known as 'The Jewish Bride' (circa 1665-circa 1669), Rembrandt van Rijn

The style in which Rembrandt portrayed the couple was modern for its day. In places, the painting looks rather rough and unfinished. Lumps of paint, sometimes put on the canvas with a wooden spatula, literally stick out from the canvas.

Rembrandt painted *The Jewish Bride* late in his career, at a stage when he had freed himself from convention. He moulded his paint, scratched in it and smeared it with a palette knife. The Dutch painter Vincent van Gogh was ecstatic about this work. He was moved by the intimacy of the painting. When van Gogh sat in front of Rembrandt's painting at the opening of the Rijksmuseum in 1885, he did not want to leave. The rough style that the old master used had a strong influence on Van Gogh's own style.

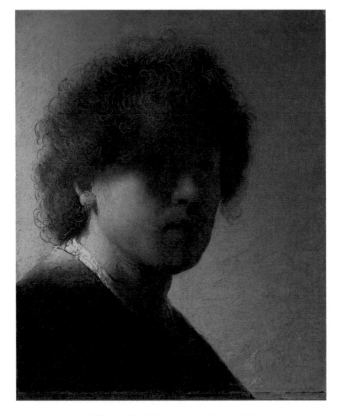

Self-portrait (1628) - Rembrandt van Rijn

This delicate small self-portrait by Rembrandt is a daring masterpiece made at the tender age of twenty-two. The eyes of the artist are almost invisible. If you observe the painting from nearby, you will notice that the curls of his hair are not painted with a brush but have actually been scratched in the still wet paint with the butt end of a brush.

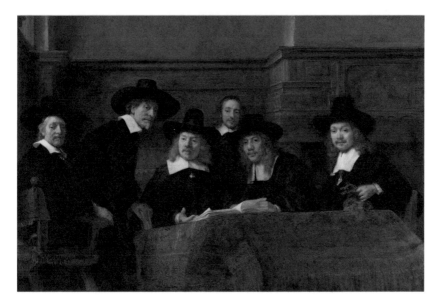

The Syndics of the Drapers' Guild (1662) - Rembrandt van Rijn

When Rembrandt received the commission to portray a group of Amsterdam guild masters, he invented a way to bring some extra life to a potentially static scene of men dressed in black.

It looks as if we, the spectators, burst into the room while the men are still consumed by their work. The men look up as if disturbed. A book with price-lists is still open on the table. The bag of money has not been put away. The second man from the left rises from his seat. Or is he sitting down? We don't know. This way, Rembrandt manages to turn a potentially boring depiction of businessmen at a table into a lifelike and informal scene.

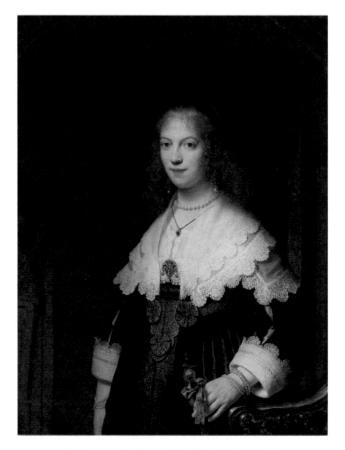

Portrait of Maria Trip (1639) - Rembrandt van Rijn

The young lady in the portrait belonged to the upper class of 17th-century Amsterdam. Her family made a fortune in the weapon and gunpowder trade. She looks us confidently in the eye, and seems to display her wealth with pride.

Everything about her radiates wealth: the fine lace on her shoulders, the pearls, gorgeous ear hangers and the folding fan in her left hand. At the time, this type of fan was a rare and expensive accessory.

Rembrandt made this portrait in 1639, at the peak of his career. With his phenomenal technique and eye for detail, he managed to create an illusion of depth.

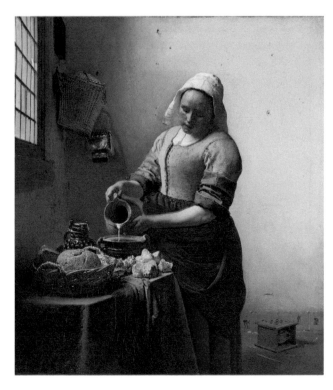

The Milkmaid (circa 1660) - Johannes Vermeer

The Milkmaid is one the most beloved works by Johannes Vermeer of Delft (1632 - 1675). We see a kitchen maid at work who is portrayed with incredible eye for detail.

A basket, pieces of bread and a foot stove on the floor are added to give a glimpse of domestic life in The Netherlands of the 17th century. The girl is a symbol of virtue and obedience. Her tanned arms indicate that she is a servant. Rich people kept their skins pale as a sign of beauty, so pale skin indicated relative wealth and some degree of privilege.

The maid stands still like a statue, and is entirely absorbed in her task, pouring milk into a bowl. She seems to be doing this with great caution. Gluttony was a cardinal sin. The primary colors in her clothes beautifully contrast with the off-white of the wall behind her.

1 **2**

Please pay special attention to the detail in the background: the scratches on the wall are not cracks in the varnish or paint, but are depictions of actual nail holes (1). If you look at the window on the left, you will notice that a piece of glass is missing (2). The woodwork next to the missing part is somewhat lighter than the rest.

Vermeer's works often have a meditative and enigmatic character. In this delicate painting we see a woman reading a letter, and activity associated with love. The woman may be pregnant but that is not certain, as dresses were supposed to make a woman look full and round. On the table a jewel box refers to vanity.

When you are in the gallery, please have a look at the way Vermeer rendered shadows on the wall. For these shadows the artist used a light blue which was rather innovative for the time.

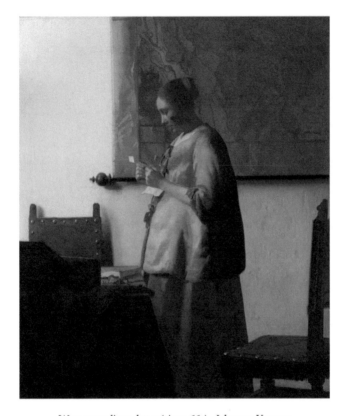

Woman reading a letter (circa 1663) - Johannes Vermeer

Unfortunately Vermeer's oeuvre is relatively small, consisting only of some thirty paintings. This indicates that he either worked slowly, or that he produced paintings with long intervals in between. The first option seems most likely, given the meticulous attention to detail in his paintings.

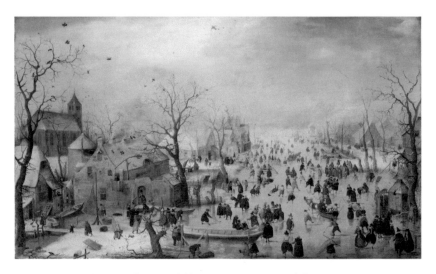

Winter Landscape with Skaters (circa 1608) - Hendrik Avercamp

Apart from soccer, ice-skating is the number one sport in the Netherlands. The country has a lot of waterways and lakes, so there is plenty of opportunity to skate in winter.

Hendrik Avercamp (1585 - 1634) was specialized in winter landscape painting. Being born deaf and mute, drawing and painting were his most important means of communication and expression.

The canvas, with its high vantage point, is packed with little stories. People skate hand in hand, fall flat on their face or play a game of 'kolf', a kind of golf on ice. There is even a horse-drawn sleigh. In the background you can see people dropping their pants to relieve themselves. A couple in love kisses in a haystack.

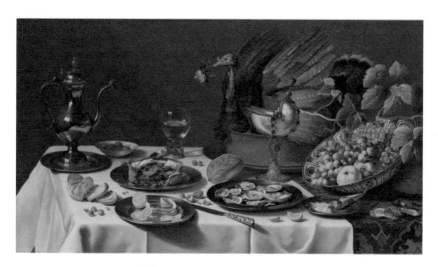

Still-life with Turkey Pie (1627) - Pieter Claesz.

Still-life painting as an independent genre first flourished in the Netherlands during the early 1600s. Still-life paintings were made to educate us. We are all mortal and time passes on. That is why you often find skulls and sandglasses in this genre of painting.

In this particular instance, Pieter Claesz depicted delicious food that is drying out. The technique in *Still-life with Turkey Pie* is breathtaking. Please pay special notice to the way the artist convincingly painted the texture of the nautilus shell and the porcelain blue and white bowl on the right. And when you are in the galleries, try to find the hidden self-portrait of Pieter Claesz. (1596/97 - 1660) in the silver teapot on the left.

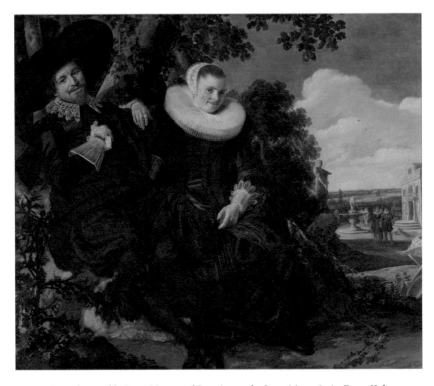

A couple, possibly Isaac Massa and Beatrix van der Laen (circa 1622) - Frans Hals

Frans Hals of Haarlem (1583 - 1666) is known for his loose and virtuoso style. Where other painters reached for perfection in detail, Frans Hals worked with swift brushstrokes, almost nonchalant and carefree. Yet, his paintings look very realistic.

This intimate marriage portrait probably represents the businessman Isaac Massa and his wife Beatrix van der Laen. The couple is surrounded by plants that symbolize virility (the thistle to the man's left) and attachment or affection (the ivy to the woman's right). In the background you can see a garden of love with young couples walking hand in hand.

This painting is a shame-free and happy display of the newlywed's love for each other. At the time, this type of intimacy in portraiture was unusual.

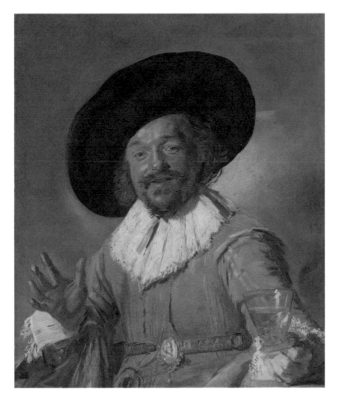

A Militiaman holding a Berkemeyer, also known as 'The Merry Drinker' (circa 1628-1630) - Frans Hals

The Merry Drinker by Frans Hals shows a militiaman holding a glass, a berkemeyer, while he is waving at us with his other hand. His blushing cheeks and slightly tilted posture indicate that this may not have been the first drink of the day. The identity of the man is unknown to us, but does that really matter?

Paintings by Hals are a marvel to look at, both from up close as well as from a long distance. If you observe the painting form up close, you see broad brushstrokes. From a further distance these strokes blend into recognizable shapes. This technique was later used by the Impressionists in the 19th century, and by one famous Frans Hals admirer in particular: Vincent van Gogh.

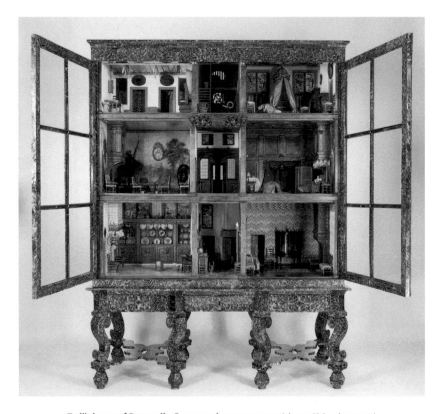

Doll's house of Petronella Oortman, by anonymous (circa 1686 - circa 1710)

Doll's houses were the ultimate luxury toy of Amsterdam upper-class ladies. This particular example was already called a 'wonder of the world' at the time. All of its contents were produced with authentic materials, and every piece of furniture and object in the house was copied from real life on a precise scale of 1 to 9.

On the outside, the cabinet is covered with tortoiseshell and pewter inlays. To acquire such a magnificent showpiece, the buyer would pay three times the price of an average canal house in Amsterdam. For art historians and researchers the doll's house is a goldmine of information, showing us exactly how the 17th-century well-to-do decorated their houses.

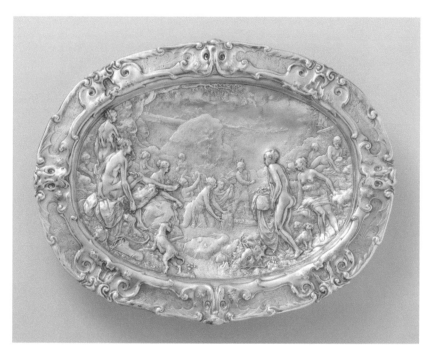

Silver basin with scenes from the story of Diana and Actaeon (1613) - Paulus Willemsz. van Vianen

This wonderful silver basin depicting a Greek myth is craftsmanship at its highest level, made by the silversmith Paulus Willems. van Vianen (1570 - 1613). You can see Diana and her nymphs taking a bath in the river, at the moment when they are being disturbed by Actaeon. This prince was lost in the forest while hunting.

The punishment for seeing a goddess naked was rather harsh: Actaeon was transformed into a stag and killed by his own friends. This killing scene is depicted on the back of the basin.

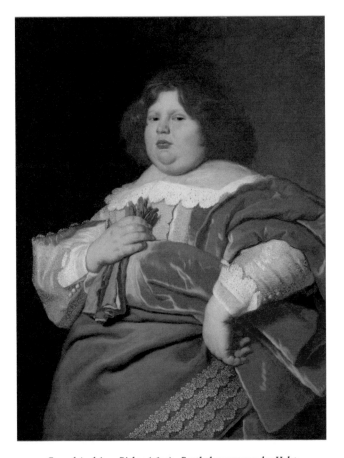

Gerard Andriesz. Bicker (1642) - Bartholomeus van der Helst

The self-assured person in this portrait by Bartholomeus van der Helst is sometimes mistaken by museum visitors to be an angry woman. He is in fact a member of the almighty Bicker family, a clan of businessmen who ruled Amsterdam for nearly 40 years.

The powerful merchants of the city considered themselves the modern version of Roman senators and dressed accordingly in portraits. The gloves in Bicker's right hand signify his sportsmanship, for they are accessories for horseback riding.

Bartholomeus van der Helst (1613-1670) was famous for his expression

of textures. By merely looking at his paintings, you can imagine what the textures of the garments must feel like on your skin.

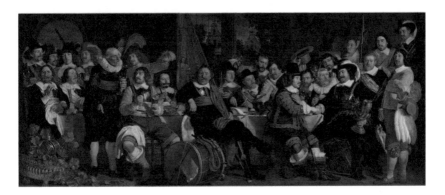

The Guild of St. George, celebrating the Peace Treaty of Munster (1648) -
Bartholomeus van der Helst

The year 1648 is generally considered to be the birth year of the Netherlands as a country. Until then, its provinces had officially been part of the Kingdom of Spain. After the 80-year war against the Spanish King, a peace treaty was signed and the 'Republic of the Seven United Provinces of the Netherlands' was officially acknowledged.

This tiny republic became the center of the world for almost a century. Amsterdam housed the biggest harbor in the world. Shareholding and the stock exchange were invented and Dutch merchants went all over the planet. Colonies were occupied and the town 'New Amsterdam' was founded, the city nowadays known as New York.

The international character of Amsterdam during this Golden Age is visible in the group portrait of the guild of St. George (above). Food and drink were imported from around the world. Red wine came from France and white wine from Germany, olives and lemons were imported from Greece and Italy, the furniture is Italian and the tablecloth was produced in Turkey.

The men seated around the table celebrate the victory over Spain. They eat, drink and shake hands. The flag bearer sits proudly at the center with the banner of Amsterdam wrapped around his shoulders. If you look closely when you are in front of this painting, you will see the famous coat of arms of Amsterdam on the flag: three white crosses on a red and black shield. Also have a look at the silver cup the man in black on the far right is holding. The cup is decorated with a knight on horseback fighting a dragon, while a princess waits to be rescued. This is Saint George, patron saint of this guild. The drum on the floor is silent, indicating that no armies will march to its rhythm anymore. Instead of making noise, the skin of the drum now carries a poem about eternal peace and prosperity.

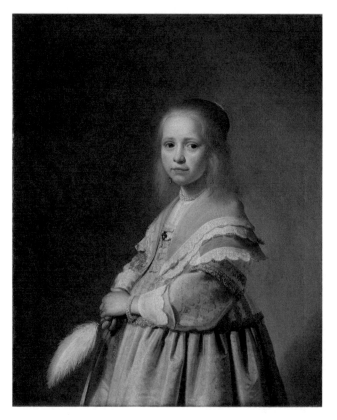

Portrait of a girl in a blue dress (1641) - Johannes Verspronck

In the 17th century, rich children were supposed to dress and behave as adults. It is not known who the girl is in this portrait by Verspronck, but she is obviously from a well-to-do family. Her dress is decorated with gold and lace and she wears pearls around her wrists. An ostrich feather fan in her hand shows her family's delicate taste and wealth. Ostrich feathers were a luxury item at the time.

Portrait of a girl in a blue dress by Johannes Verspronck (1597 - 1662) is popular with both connoisseurs as well as general museum visitors. The look in the girl's eyes is touching; her blushing cheeks and loose hair give her a youthful and innocent appearance.

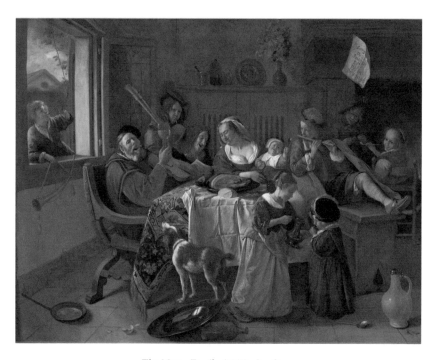

The Merry Family (1668) - Jan Steen

Jan Steen (1625 - 1679) is perhaps the most popular Dutch painter after the 'Big Three', Rembrandt, Vermeer and Frans Hals. Reason for this popularity is Steen's talent to portray lively scenes with people enjoying themselves. He was a born story-teller, which make his paintings a joy to look at.

Although the merry, boisterous family shown here is a great example of this talent, Jan Steen does not promote hedonism and self-indulgence. On the contrary, a painting like this should warn against the dangers of alcohol and lack of self-control.

Looking closely, we see a drunken father singing, the violin slipping from his shoulder. His wife and his mother sing along while a man with bagpipes accompanies them. Nobody seems to be looking after the children, so they make a party of their own, smoking, climbing on the table and drinking. The toddler wearing the green dress gets some wine from his sister.

Over the fireplace at the upper right, a sheet of paper gives away the moral:

'Soo de ouden songen, so pypen de jongen'.

In other words: monkey see, monkey do.

The 18th-century portrait painter Sir Joshua Reynolds, President of the Royal Academy in London, described Jan Steen as follows:

"...if this extraordinary man had had the good fortune to be born in Italy, instead of in Holland, had he lived in Rome instead of Leiden, and been blessed with Michelangelo and Raphael for his masters instead of Brouwer and Van Goyen; the same sagacity and penetration which distinguished so accurately the different characters and expression in his vulgar figures would, when exerted in the selection and imitation of what was great and elevated in nature, have been equally successful; and he now would have ranged with the great pillars and supporters of our Art."

Reynolds was obviously offended by Jan Steen's vulgarity. We now know that Steen's paintings are carefully staged and always carry a moralistic message.

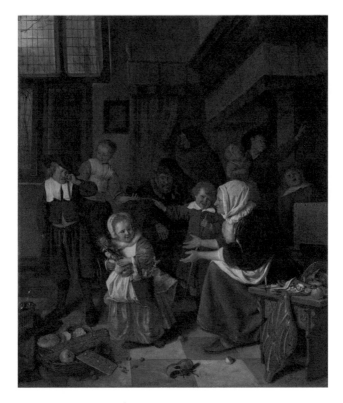

The Feast of St Nicholas (1665-1668) - Jan Steen

Another painting by Jan Steen is this depiction of the feast of St Nicholas. This popular feast has already been celebrated for centuries in the Netherlands. Every year on the 5th of December, good children are rewarded for their behavior and bad children are punished. It is very clear in this painting which child has been good.

The little girl has received a bucket full of sweets and has a doll in her hands. The boy sobs, being teased by his older sister. He did not receive any presents.

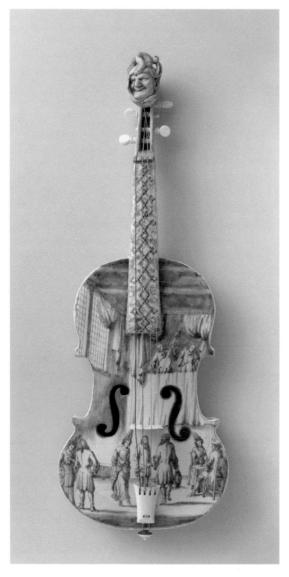

Dutch earthenware violin, by anonymous (circa 1705 - circa 1710)

Dutch earthenware was originally produced as a cheap copy of refined China porcelain, but soon became a popular item of its own. The texture of Dutch clay does not allow the production of really thin objects, but a Chinese appearance can be faked with glaze. The

earthenware is abundantly decorated. The tin-glazed violin shows people dancing to music and playing cards in a public house. It cannot be played; it is a decorative object.

In 1876 the collector John Loudon paid a record 1500 Dutch guilders for this object which was considered to be an exceptional example of Dutch earthenware.

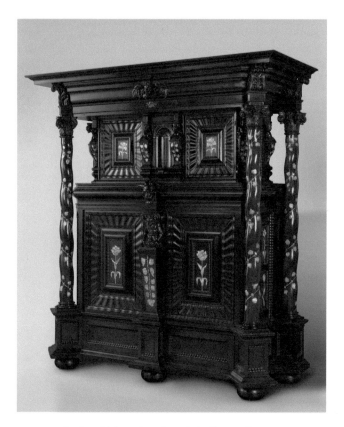

Cupboard (circa 1635 - circa 1645) - Herman Doomer

The rich merchants of Amsterdam did not only show off their wealth with collections of paintings, silver and porcelain, but also with luxurious furniture.

This cupboard was made by Amsterdam's most famous cabinetmaker

and ivory carver Herman Doomer (circa 1595 - 1650), using oak and various kinds of exotic wood, such as ebony, rosewood and acacia. The decorations are made of ivory and mother of pearl.

Doomer's workshop also produced picture frames. It is likely that Rembrandt was one of its customers. Rembrandt and Doomer knew each other and Rembrandt painted portraits of the German-born Doomer and his wife. These portraits are at the Metropolitan Museum of Art in New York.

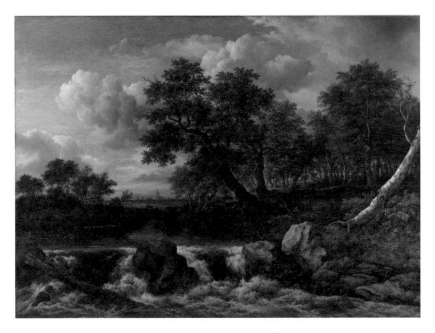

Landscape with waterfall (circa 1668) - Jacob van Ruysdael

Dutch landscape painting became very popular with art lovers in the 17th century. For lack of spectacular mountain ranges in the Netherlands, Dutch painters looked for drama in the depiction of clouds: grey, big and heavy they hang over the landscape. The paintings thus got a theatrical 'larger than life' quality.

Both paintings shown here were made by the artist and doctor Jacob van Ruysdael (1628 - 1682). Interestingly, landscape paintings were not

made in the open air. Artists made sketches outdoors and produced the final painting in their workshops, often copying from colleagues.

If you are in the gallery, look for the tiny figures in the grandiose landscape with waterfall. Their small size further enhances the magnificence of nature with its impressive gnarled trees, rolling water and tree trunks.

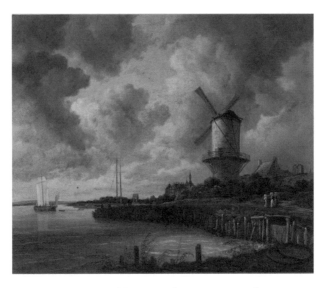

Windmill at Wijk bij Duurstede (1668-1670) - Jacob van Ruysdael

Is there a more typically Dutch landscape than the *Windmill at Wijk bij Duurstede*? With its majestic windmill, low horizon, broad expanse of the river and impressive sky with dark rain clouds, there are few paintings more Dutch than this. One would think that windmills are often depicted in paintings of the Low Countries, but this is actually one of the few painted representations of windmills around. The image of the windmill as a typical feature of the Dutch landscape only came into existence in the 19th century.

THE REMBRANDT HALL WITH THE NIGHT WATCH

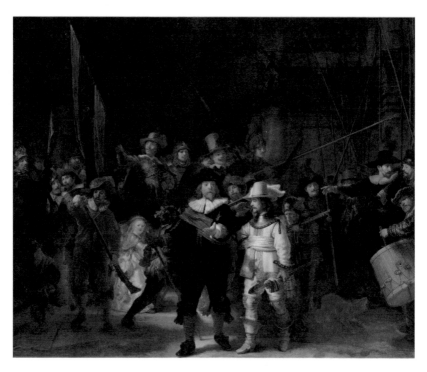

The civic guard of captain Frans Banninck Coq, known as 'The Night Watch'
(1642) - Rembrandt van Rijn

At the end of the Gallery of Honor you will find the Rembrandt Hall. This is the most important hall of the Rijksmuseum and entirely dedicated to Rembrandt's masterpiece *The Night Watch*.

In the Republic of the 17th century, the 'burghers' or citizens defended their own cities. The richest businessmen were also the captains of the civic guards. In this painting we see one of those companies, the 'Kloveniers', set off to march.

The painting is an incredible display of movement and light. Nobody poses for the painter but all the men march, talk, prepare their guns or wave a flag. A little girl carrying a dead chicken runs into the scene. A young boy carries the gunpowder for the soldier charging his gun on the left. The drummer starts beating the rhythm to which the soldiers will march.

The painting is a snapshot. With his famous use of light effects, Rembrandt created a scene that is almost three-dimensional. The figures are life-size and move informally and naturally. It was already very popular to be portrayed in a slightly informal and relaxed manner, but Rembrandt perfected this. The result is astonishingly realistic. Pay special attention to these details when you are standing in front of *The Night Watch*.

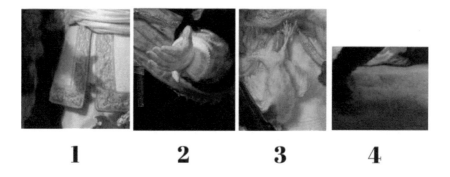

1 **2** **3** **4**

The 3D-effect: The outstretched arm of the captain in the center casts

a shadow (1) on the yellow tunic of his lieutenant. The open hand (2) catches the sunlight and seems to stick out of the canvas. The yellow uniform and white scarf are painted with microscopic detail.

The shadow of the hand 'grips' a lion standing on its hind feet in the embroidery of the uniform. The lion holds a shield with three crosses on it: the coat of arms of Amsterdam. With minuscule brushstrokes Rembrandt depicts the embroidery in full detail.

Behind the captain a small soldier fires a gun. Only his curved leg and his shining helmet are visible. The helmet is adorned with oak leaves, the symbol of victory.

Left, we see a girl with a chicken on her belt. The chicken's feet ('clauwe') (3) symbolise the army of 'clauweniers' ('Kloveniers'). The girl resembles Rembrandt's first wife Saskia, but it is not 100% certain it is her. Under her foot the painter signed 'Rembrandt f(ecit) 1642' (4).

The location of the painting in the museum building is symbolic. The museum itself has been designed like a cathedral, with the Gallery of Honor being the nave and the rooms around the gallery serving as chapels. The Rembrandt Hall is located where in a cathedral one would find the altar. It is therefore the most 'sacred' place of the building.

The center of this hall is of course *The Night Watch* itself, but there is more. The decorations in the Rembrandt Hall around this painting are glorifications of the painter's life and works. Standing on separate columns, statues with veils symbolize the four periods of the 24-hour cycle: Evening, Night, Morning and Day. The darker the moment of the day, the more the statues cover their faces.

Rembrandt was the master of light and dark, all different light tones are present. Rembrandt's life story is painted in golden letters over the dark walls. The ceiling is covered with symbols of nature, just like in the Front Hall and the Gallery of Honor.

MEDIEVAL AND 16TH-CENTURY ART

The Rijksmuseum has combined its objects of medieval and Renaissance art in one exhibition. You will find this section in the basement of the building.

Dutch history is not particularly well-known for its medieval and Renaissance art. The more famous developments in art and science in the Netherlands took place after that period, in the 17th century, the Golden Age. The centuries preceding this blooming period are less well-known, which is unjustified. It is a rich age with some exceptionally beautiful objects and paintings.

The central subject in this exhibition is religion. In the Middle Ages, religion is everywhere in daily life. Christianity is a world power with political influence. Churches are the most important and visible buildings in every European city.

The objects of the medieval art section tell the stories of the lives of Jesus, Mary and Joseph, as well as biblical tales with a moral. Various saints are represented by statues and relics. Religious objects were made for use in public spaces like churches and town halls but also for private use in a domestic setting.

The art works of the 16th century show a shift towards a more human-centered world. Individualism results in the production of self-portraits and the depiction of real people. Interest in ancient cultures becomes visible by depictions of Venus and other pagan figures. We also see developments in style and technique. Objects become more realistic, and the human figure is rendered with more movement. Influence from Italian artists is recognizable in perspective, volume and a more lifelike depiction of the human body.

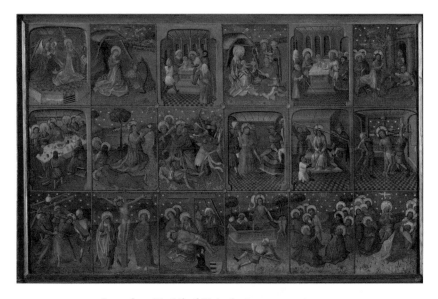

Scenes from The Life of Christ, *by Anonymous, circa 1435*

The first object you should take some time for is this depiction of the life of Christ. One could call it a 15th-century cartoon strip, displaying all the important scenes from the Gospel. It was made in a century when reading and writing were exclusively the domain of the nobility and the clergymen. Ordinary people could learn about Jesus and other biblical stories by studying panels, sculptures and stained glass windows. Like a Marvel Comic this panel shows us the life and works of Jesus Christ, from the Annunciation of Mary at the top left to the Messiah's crucifixion and resurrection at the lower right.

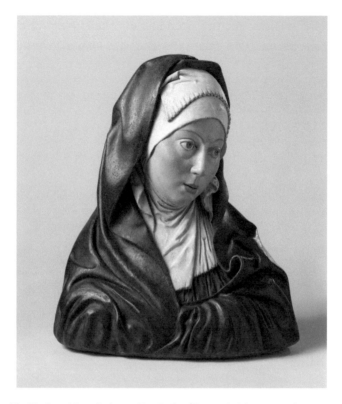

The Virgin as Mater Dolorosa (Our Lady of Sorrows), (circa 1507 - circa 1510),
attributed to Pietro Torrigiani

This terra-cotta bust of a weeping woman represents Mary, the mother of Jesus. People in the Middle Ages would immediately recognize her by the blue and white garment. This is the only known bust of this type in the Netherlands.

Her slightly tilted head testifies to the grief of the *Mater Dolorosa*, the Lady of Sorrows, crying at the foot of the cross where her son had died. Without extreme facial expressions or postures, her grief is shown with restraint and cool.

Traditionally, one could encounter a crying Mary in paintings rather than in sculptures. It is a good example of the Northern European style. The bust has been attributed to Pietro Torrigiani, an Italian living in Bruges where he was in the service of the Archduchess

Margaret of Austria. For the Archduchess the subject of a grieving female was particularly relevant since she was a grieving widow herself.

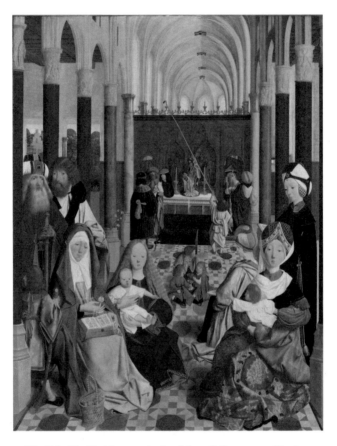

The Holy Kinship (circa 1494) - (workshop of) Geertgen tot Sint Jans

The Holy Family consisted of nineteen people. In this painting we see all of them together, set in an imaginary medieval church. Mary in the blue dress with Jesus on her lap modestly sits just left of the center. Her mother Anne sits nearby, holding a book. Behind them on the left, we see their husbands Joseph and Joachim. The two figures on the right are Mary's cousin Elizabeth who is holding her son, John the Baptist, on her lap. John the Baptist points his little finger at Jesus. In the

background we see Mary's sisters accompanied by their husbands and children.

It is a wonderfully detailed painting. Take a closer look at the golden statue on the altar, representing Abraham sacrificing Isaac. The screen behind the altar shows the origin of worldly sin: the temptation of Eve by the snake and the expulsion from Paradise. John the Baptist in the foreground points at Jesus: 'He is our Saviour'. These elements foretell the sacrifice that Jesus will make years later to relieve the world from its sins.

Another detail worthwhile observing: some parts of the painting have been restored. The difference between the original painting and modern retouches is visible. Look for the thin grey lines in the colors.

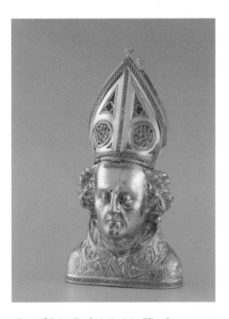

Bust of Saint Frederic (1362) - Elias Scerpswert

This silver bust is both a reliquary and a portrait of Saint Frederic of Utrecht. Once it contained part of the skull of this holy bishop who got murdered in 838 AD. On holidays, the bust would be shown to the people together with the skull fragment.

Unlike other busts where saints are depicted with almost abstract features, this particular example is more lifelike. Frederic has wrinkles in his face, stubbles and a balding crest. The silver bust is known as a 'speaking reliquary'. Underneath his body a silver plate is added with the inscription:

'The dean and chapter of the Salvator Church [...] had me exhumed in 1362 AD [...]'

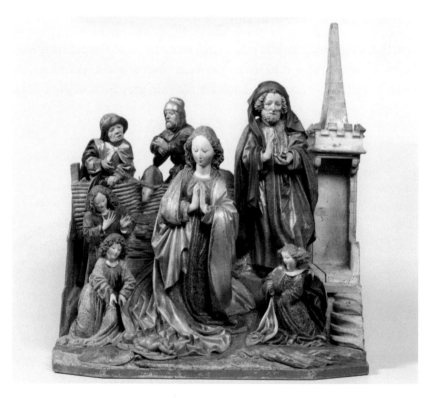

The Nativity (circa 1470) - attributed to Hans Kamensetzer

Throughout the ages, the representation of the Christmas story and its characters has become more and more 'ordinary', with lifelike figures. In this gracious wooden nativity group we see Mother Mary praying, while baby Jesus is lying on a fold of her mantle. Joseph holds a candle

and protects the flame from the wind. Shepherds and singing angels complete the scene. The artist who carved this set has been successful in rendering an elegant, realistic group of convincing proportions.

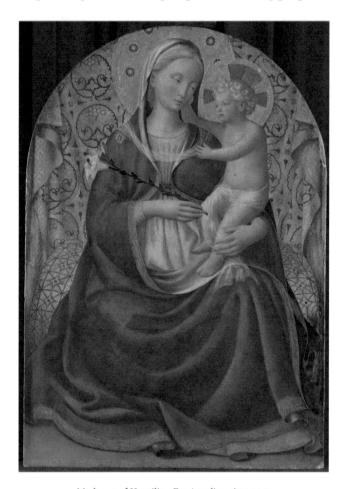

Madonna of Humility, Fra Angelico, circa 1440

This depiction of the Madonna with Jesus was made by the famous monk and painter from Florence, Fra Angelico (1400 - 1469). Since Mary is seated on a cushion and not on a throne she symbolizes humility and approachability.

The halos around their heads, decorated with punched circles and without perspective, are typical of the style of Fra Angelico.

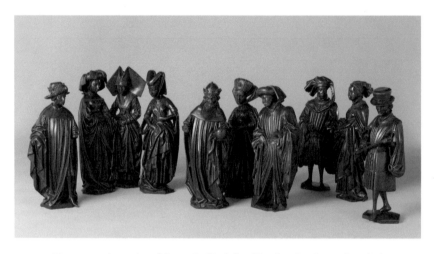

Mourners as decoration of the tomb of Isabella of Bourbon (1476) - attributed to) Jan Borman (?) and (attributed to) Renier van Thienen

These sculptures are so-called 'pleurants' or 'weepers', and once decorated the tomb of Isabelle of Bourbon who died at the age of twenty-nine in 1465. All figures represent family members or ancestors. Only ten out of the original number of 24 weepers have survived.

Mourning was a strict ritual in which everyone played a specific role. Public display of emotions was frowned upon. One had to keep his posture and express grief in a controlled manner. Therefore the figures are solemn and pensive.

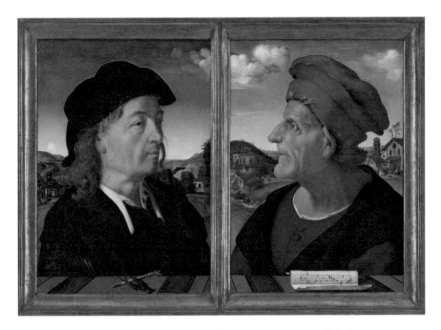

Giuliano and Francesco da Sangallo (circa 1482-85) - Piero di Cosimo

In the Renaissance, mankind shrugged off anonymity. God and the saints were no longer the only subjects of art. Recognizable, 'real' people took to the stage, showing their name, profession and status.

This double portrait is a great example. On the left we see the architect Giuliano da Sangallo, the master builder of St. Peter's basilica and good friend of Michelangelo.

A pair of compasses and a pen in front of him represent his métier. The man on the right is Giuliano's father, the architect and composer Francesco Giamberti da Sangallo. His occupation is symbolised by a sheet of music. In the background our eyes can dwell on a delightful Tuscan landscape.

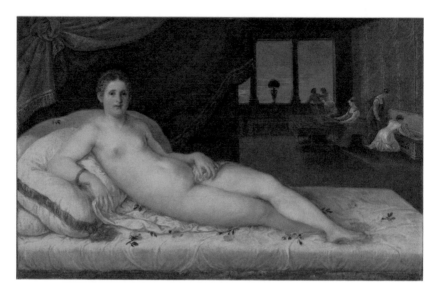

Lying Venus (circa 1540-1560) - Lambert Sustris

The Dutch painter Lambert Sustris (circa 1515 - after 1568) was one of the close collaborators of the Venetian master Titian (1487 - 1567), whose *Venus of Urbino* he copied.

Whereas a goddess was usually portrayed as unapproachable and distant, the Amsterdammer Sustris placed the nude Venus in an informal setting, a Renaissance residence with employees working in the background, thereby making her more human.

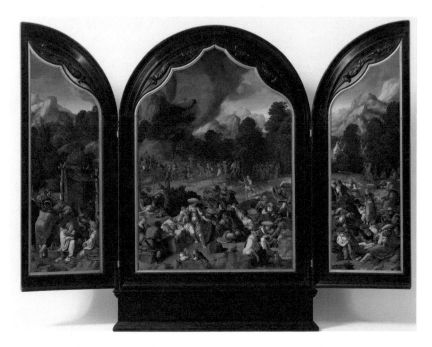

The Adoration of the Golden Calf (circa 1530) - Lucas van Leyden

This triptych, showing the adoration of the golden calf as described in the book Exodus, is full of movement and a feast for the eyes. Having lost their faith in God, the Israelites created their own idol to worship. They lost their decency and morality and started drinking, partying and making love in the open. Yahweh was very angry that the Israelites had made the Golden Calf and that they were adoring another god. Moses had all of them killed.

It contains wonderful details depicting debauchery: the drinking, the puking and the dancing. One woman looks us right in the eye, as if to invite us to join in. Everywhere you look, you see skin and shapes of fleshy bodies, belly buttons and butt cheeks. In the middle panel a woman in a blue dress offers an apple to a man next to her. It is the fall into sin all over again.

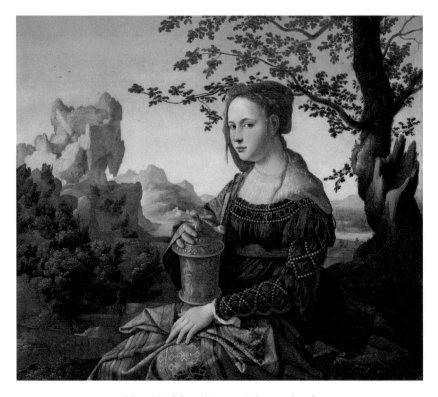

Mary Magdalene (circa 1530) - Jan van Scorel

In this picture by Jan van Scorel (1495 - 1562), Mary Magdalene is portrayed holding the pot containing the ointment for Jesus' feet. She is elegantly dressed, referring to her past as a high-class prostitute.

In the background the painter depicted her a second time. According to legend, after Jesus' death she lived as a hermit for the rest of her life. Every day, angels would lift her up and show her future life in heaven. Almost invisible (surely in this book, but even in real life), that scene is depicted against the rocks in the distance.

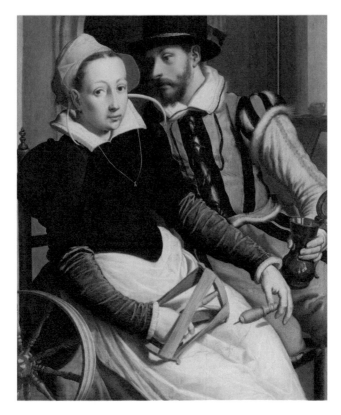

Man and Woman at a Spinning Wheel (circa 1565) - Pieter Pietersz.

The scene in this painting is what we can call a 'cliffhanger'. A woman at a spinning wheel is interrupted by a man offering her a drink. She looks at the spectator, as if to ask us what to do. We will never know her decision.

Even though the Church's influence on everyday life weakened in the Renaissance, painters like Pieter Pietersz. (circa 1541 - 1603) still added morality to their works. Virtue versus sin, pleasure versus discipline. If you compare this work with medieval paintings, you see a distinct development. Now, there is volume, perspective and refinement.

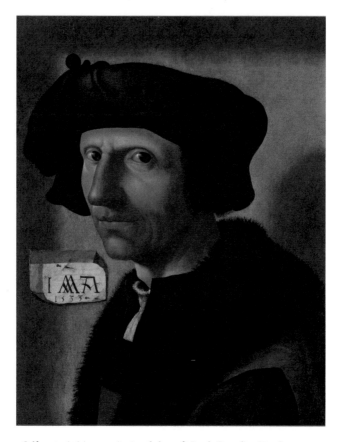

Self-portrait (circa 1533) - (workshop of) Jacob Cornelisz. Van Oostsanen

This bust-length painting is often considered to be the oldest known self-portrait in the Netherlands. The original must have been older but is unknown to us. The painting in the Rijksmuseum, made on a plank, in all likelihood is a copy.

The painter depicted is Jacob van Oostsanen (circa 1472 - 1528), who shows his social status and self-confidence by portraying himself as a well-dressed man who looks us right in the eye. He is wearing a black bonnet with earflaps, and a fur-trimmed dark gown over a white shirt with a gathered collar and a red jacket.

In the Renaissance, artists were more than just craftsmen working for the Church or the King. They were individuals with a soul and a

voice, and their own signature, both literally and figuratively. On the sheet of paper on the wall he wrote his initials **I W** (inverted) v **A**.

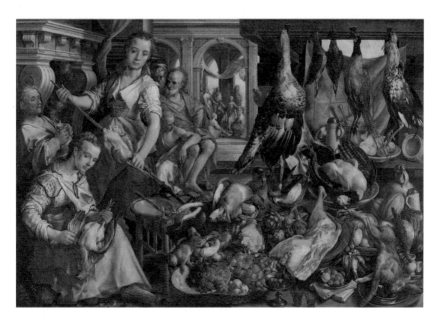

The well-stocked Kitchen (1566) - Joachim Bueckelaer

The kitchen in this painting shows us wealth and abundance, displaying meat, poultry, vegetables and exotic food everywhere. There are jars and plates and two women preparing a chicken dish. It may look like an invitation to enjoy life's delights, there is a catch. The subject of this painting is not about a display of food and abundance. Just have a look at the background and you will see Jesus visiting the two sisters Mary and Martha. That is the real subject of the painting, while the artist used the kitchen setting as an excuse to paint food and objects.

In the original Bible story Mary sits and listens to Jesus' teachings, while Martha gets up and prepares dinner. Jesus tells them that Mary's way is the right way to react. She does not care about worldly matters, but sits still to focus on the spiritual message.

"As Jesus and his disciples were on their way, he came to a village where a woman named Martha opened her home to him. She had a sister called Mary, who sat at the Lord's feet listening to what he said. But Martha was distracted by all the preparations that had to be made. She came to him and asked, "Lord, don't you care that my sister has left me to do the work by myself? Tell her to help me!" "Martha, Martha," the Lord answered, "you are worried and upset about many things, but few things are needed—or indeed only one. Mary has chosen what is better, and it will not be taken away from her."

Between background and foreground there is a third element: old men dressed like Romans, presumably discussing, symbolizing virtue.

This kind of rhetoric is often used in 16th-century art. The combination of everyday life in the present with an age-old message from the Bible.

The painter is Joachim Bueckelaer (1533 - 1575), whose 'kitchen scenes' were popular at the time.

18TH-CENTURY ART

The 18th century is the age of refinement. The Netherlands have lost their position as a leading world power but are still a rich country. Families who made their fortune in the Golden Age spend their money on art.

As you will see in this section of the Rijksmuseum, the 18th-century upper class turns its houses into artworks as a whole. Whereas the 17th-century elite would simply decorate their walls with paintings, that did not do for the generations after them. Having your own art collection in a beautiful house is a matter of prestige. Knowledge of and love for music, literature and visual arts are all part of one's status.

The main influence on these developments is the royal court in France. The Dutch imitate French fashion by wearing wigs and costumes of the nobility. Houses and gardens are designed in the French style, and people speak French. Therefore, this is not an 'exclusively Dutch' exhibition, like in the 17th-century section.

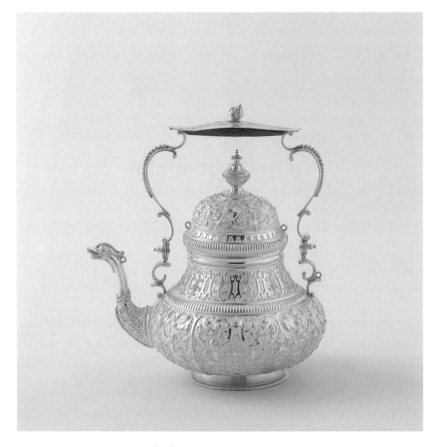

Tea kettle (1738) - Gabijnus van der Lely

An important part in this lifestyle is played by a particular room in the 18th-century house, the Salon. Here one can lavish his wealth and good taste on his visitors. It is the room to discuss politics, art and science. Concerts take place in the Salon as well as lectures, debates and card games. Tea and wine are served in elegant silver and porcelain sets. Household objects are turned into art, the beginning of 'applied arts'.

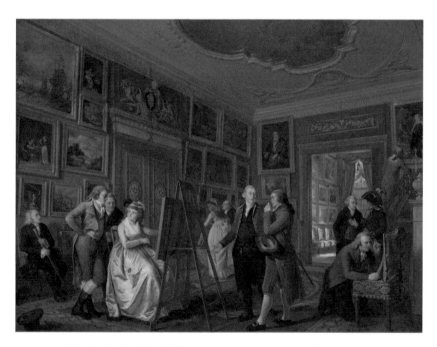

The Art Gallery of Jan Gildemeester (circa 1794 - 1795) - Adriaan de Lelie

The merchant Jan Gildemeester bought a luxurious canal house on Herengracht in Amsterdam in 1792. Two rooms of this house were decorated as an art gallery, with paintings hanging frame to frame. Modern museums still had to be invented. For a long time, art collections were a personal business.

Jan Gildemeester is portrayed in the middle, wearing a blue and gray suit. He is in conversation with an man in a red jacket. The other visitors take their time to look at the paintings in the room.

The scene is informal and relaxed. Not only can we admire the painter Adriaan de Lelie (1755 - 1820) for his technique, we also get a glimpse on what the art lovers of the 18th century collected.

By observing the painting closely, you can recognize the works on the wall. The gentleman standing on the stairs in the background on the right is studying *Man With Falcon* by Rubens up close. Over Jan Gildemeester's head we see Rembrandt's *Preacher*. Also visible are

landscapes by Ruysdael and Hobbema and paintings by Metsu, Dou
and Terborch.

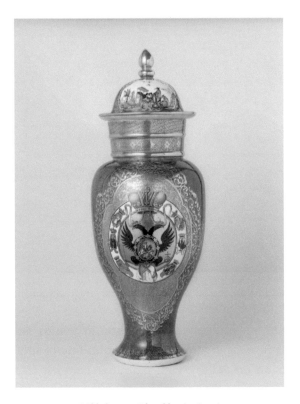

Lidded vase with gold paint (1727)

This blue vase is one of the top pieces of the Meissen collection in the
Rijksmuseum. It has been lavishly decorated with gold paint and
mother of pearl glaze.

On the lid we see a so-called 'chinoiserie': a Chinese-looking
decorative element. The Russian coat of arms has been painted onto
the vase itself; in 1728 August the Strong sent this vase as a gift to the
Russian court.

Until the 18th century, porcelain was exclusively a Chinese or
Japanese product. The mineral kaolin, essential for making porcelain
because of its fine structure, was only found there. When kaolin was

also discovered near the German town of Meissen at the beginning of the 18th century, it kick-started the European porcelain production.

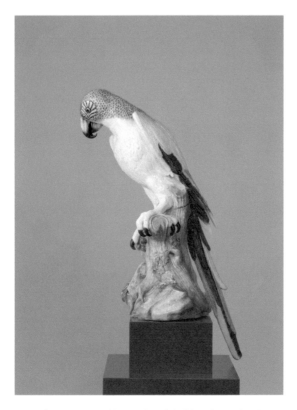

Blue Macaw - Meissener Porcelain Manufactur (1731)

This porcelain bird was owned by the Elector of Saxony, August the Strong (1670 - 1733), a lover of birds. His two passions, porcelain and exotic animals, were combined in the many animal figures that decorated the walls of his palace in the Japanese style.

If you look closely at the bird when you are in the gallery, you will notice that it has been painted over, but not entirely. This way, there is visible proof that the object is really made of porcelain.

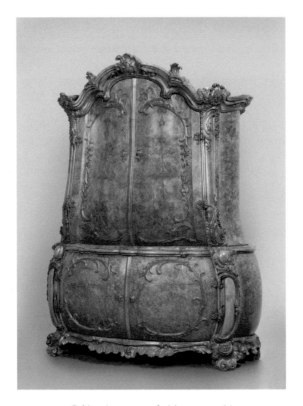

Cabinet in rococo style (circa 1755-1765)

This oak cabinet is a great example of the so-called 'rococo' style: curved shapes and asymmetric floral ornaments. The cabinet has not one straight line in it, everything is curved. The decorative elements are shaped like leaves, which is typical for the era. Even the keyholes are surrounded by decorations. One could view it as as a piece of sculpture rather than as a cabinet.

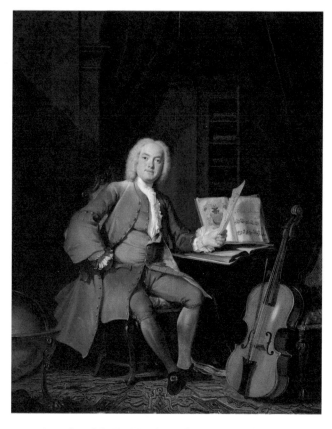

A member of the Van Mersch Family (1736) - Cornelis Troost

This is the ultimate 18th-century gentleman. Dressed in the latest French fashion and wearing a wig, he sits comfortably in his study, showing us his wealth and education.

Everything in the room around the sitter suggests refinement. The book on the table and the cello testify to his love for music, the globe on the left to his interest in geography. He is dressed like a nobleman, with his silk stockings, knee-high trousers and long jacket with a lot of buttons. The more buttons, the fancier. Wigs were powdered with flour or chalk. Some of that powder landed on his shoulders, but it was not against etiquette to show it.

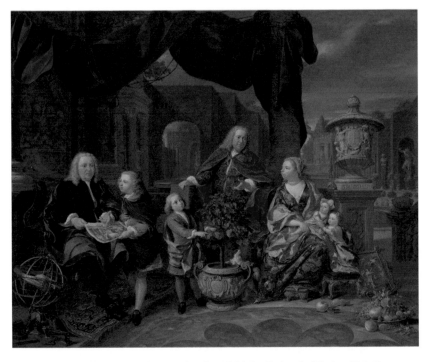

David Mollem and Jacob van Sijdervelt with his family (1740) - Nicolaas Verkolje

Gardens were also designed in a French manner. In the family portrait by Nicolaas Verkolje we see an imaginative French garden consisting of infinite sight lines behind the triumphal arch. The bushes are well-trimmed and the garden is decorated with marble vases.

Unlike the portrait of the gentleman above by Troost, the man on the left is dressed in somber black, apparently because of his strict religious beliefs. The painting breathes an atmosphere of informality, with a casual and open body language.

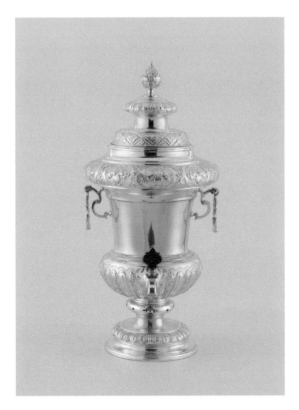

Coffee jar with tap (1729) - Andele Andeles

Coffee and tea made their way into Europe in the 18th century. To pour the coffee, one used little tanks with a tap. In Dutch, this type of object is called a *kraantjeskan*, or 'jar with tap', its design being inspired by the so-called 'wine fountains'.

The artist who made the silver coffee jar is Andele Andeles (1678 - 1754) who got his inspiration from drawings by the French engraver and architect Daniel Marot (1661 - 1752).

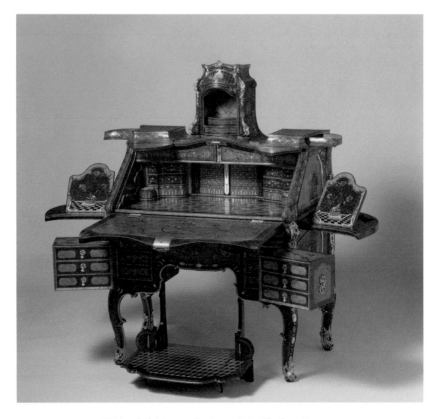

Writing desk (circa 1758 - circa 1760) - Abraham Roentgen

This desk is both a practical object and a marvel. It contains hidden drawers, openings and secret buttons to push, a specialty of Abraham Roentgen (1711 - 1795). It can even be used as a praying stool. One could kneel on the footrest. The inlay decoration looks like a three dimensional jigsaw puzzle - which it actually is. This has been achieved by a clever technique. The different inlay materials, like wood, tin or turtle shell, are glued on top of each other, with paper sheets between the layers (think of an expensive artistic lasagna). The design for the decoration is drawn on the top layer of the glued materials. The last step is to saw out the design, all layers at once, so you get multiple jig saw puzzles in exactly the same pattern. The little parts are now taken apart and glued onto the table, each part of the material of your liking.

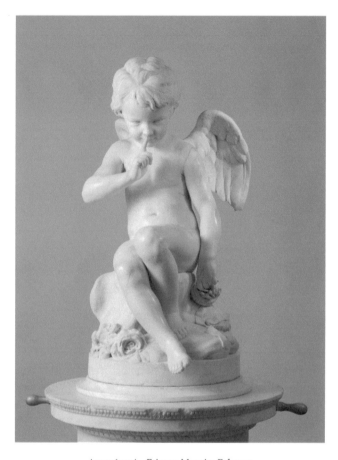

Amor (1757) - Etienne Maurice Falconet

Madame de Pompadour, mistress of King Louis XV, ordered this sculpture of 'Cupid as a menacing love' from Etienne Maurice Falconet (1716 - 1791). A quote by Voltaire is written below the smiling cherub: 'Whoever you are, this is or should be your master'.

Seated on a cloud, putting his finger on his lips, he takes an arrow out of the quiver behind him. Someone is going to fall in love soon and we are his accomplice. It is sometimes believed that the fingertip is also a symbol of hiding an affair. Look at his lifelike wings. It seems likely that Falconet examined real bird wings.

19TH-CENTURY ART

In the Netherlands the 19th century officially starts a little too early..! In 1795, inspired by the French Revolution the Dutch sack their regents and noble families to form their own democratic 'Batavian Republic'. It is the official end of the previous Republic that was so proudly established in the 17th century. What follows is a century (plus five years) of political upheaval and revolutions.

The revolution of 1795 is militarily supported by France. The Netherlands become a puppet state of the French Republic. In 1806 the country officially becomes a Kingdom under the rule of the French. This rule ends in 1813, when Napoleon is defeated and sent to the island of Elba. The independent Netherlands form a united Kingdom together with Belgium and Luxemburg. After the battle of Waterloo in 1815, Napoleon's power is over. Belgium and Luxemburg leave the Dutch Kingdom in 1839 and 1890. What remains at the end of the century is the country 'the Netherlands' as we now know it.

The swift power changes and constantly renewing political insights inspire painters and artisans. Artists like Jan Willem Pieneman and Joseph Paelinck portray the rulers of the French period. Art is heavily supported by the powerful. In the second half of the century,

Socialism and Realism will influence painters and writers. Everyday people will catch their attention.

The 19th century is the era in which the Dutch discover and reinvent their own history and identity. This is the spirit of the age: all over Europe nation states form themselves, each with their own ethnography, art and national history. In art, it means that the past is shamelessly glorified and ancient styles are copied and embellished: the so-called 'neo styles'.

Rembrandt is given a status of divinity, alongside a huge statue in the center of Amsterdam. To round it off, in 1885 the Dutch construct the largest building ever made in the country, designed to house the national collection of artworks and historic objects: the 'National Museum of History and Art' also known as the Rijksmuseum.

Besides the glorification of the past there is a bustling breakthrough to the modern era. The end of the century will see the development towards modern art by the only Dutch painter that will equal Rembrandt in fame and influence: the self-taught Vincent van Gogh. Also on display in this section of the museum are artworks from the colonies under Dutch rule in the 19th century.

The depiction of the battle of Waterloo is the largest painting in the Rijksmuseum. It shows the crucial moment in the fight that brought down Napoleon. The Duke of Wellington in the middle, seated on his horse, hears of the arrival of his Prussian allies. He points in the direction of the French army as a signal to charge. On a stretcher on the left we see the wounded prince Willem Frederik of Orange who would later become King Willem II of the Netherlands. He looks confident and relaxed, knowing that victory is near. Later he would become known as the 'Hero of Waterloo'. Less fortunate is the English colonel De Lancey, seen in the front right. He would die a few minutes after hearing the good news.

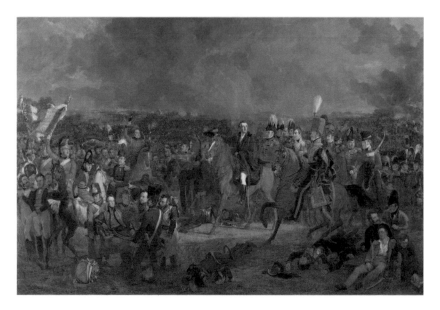

The Battle of Waterloo (1824) - Jan Willem Pieneman

On the far left we see the French general Cambronne, the loser of the battle. Almost invisible next to the tower in the background is Napoleon. He can be identified by his cocked hat and white horse. The painter Jan Willem Pieneman (1779 - 1853) aimed not only to show victors and losers but also the grim atmosphere of the battlefield. Grey clouds hang over the landscape densely packed with people.

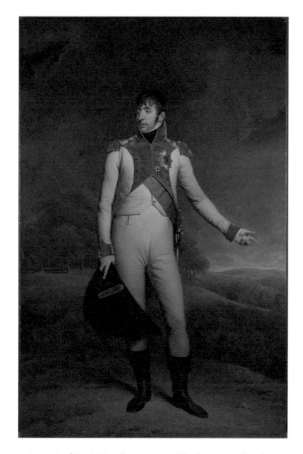

Portrait of Louis Napoleon (1809) - Charles Howard Hodges

The first King of the Netherlands was not Dutch, but French. Louis Napoleon, a brother of Napoleon Bonaparte was appointed 'King of Holland' in 1806, when the country was taken by the French. In spite of being the representative of an occupying power, he was named 'the good King'. He supported the arts and reformed tax laws and civil laws. In cases of disaster, such as explosions in factories or floods, he was present to help and give money to those stricken. He made Amsterdam the capital of the country and turned the Town Hall on Dam Square into his palace.

He also tried to speak Dutch, which resulted in a famous speech

where he called himself 'King of Holland' ('Koning van Holland). His French accent made 'King' (ko*ning*) sound like 'rabbit' (ko*nijn*), but he was forgiven for this mistake. It only added to his popularity.

In the painting by Hodges (1764 - 1837) Louis shows he is a normal man in spite of his status. He is not portrayed in a castle wearing luxurious clothes but outdoors wearing a colonel's costume. His left hand used to hold a staff but that has been retouched. Looking closely you can still see the traces on the canvas. Also note the scar under his left eye, a souvenir from the many battles he fought for his brother. Louis Napoleon had the national art collection in The Hague moved to his palace in Amsterdam. This collection formed the core of what later became the Rijksmuseum.

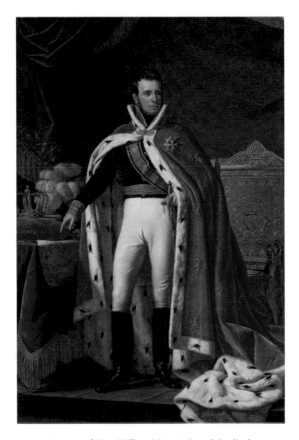

Portrait of King Willem I (1819) - Joseph Paelinck

After the first defeat of Napoleon in 1813, the 'United States of the Netherlands' were formed, a Kingdom consisting of the Netherlands, Luxemburg and Belgium. The first King of this country is shown here: Willem I. He also ruled over the colonies of the Dutch: the East Indies, the Dutch Antilles and Surinam. In this portrait he points at a map showing the East Indies with its capital Batavia, now Jakarta. He is dressed in an ermine cloak, with his crown on the table. This is the leader of an empire.

Willem I was the 'Merchant King'. He founded the Dutch Bank and the Dutch-East India Trading Company. During his reign, canals, roads and bridges were built. The colonies were forced to export 20 percent of what they produced to the Netherlands, which stimulated the Dutch economy.

Willem I also believed that art was an important factor in society. Not only did he enlarge the art collection already formed by Louis Napoleon, he also founded institutions for art education, the Royal Academies. He installed two museums, one in The Hague, now known as the *Mauritshuis*, and one in Amsterdam, the current *Rijksmuseum*. He bought 300 more paintings during his reign.

In spite of his efforts to build a new country, Willem I was unsuccessful in keeping his country unified. In 1839, the southern provinces split from the Kingdom to form Belgium.

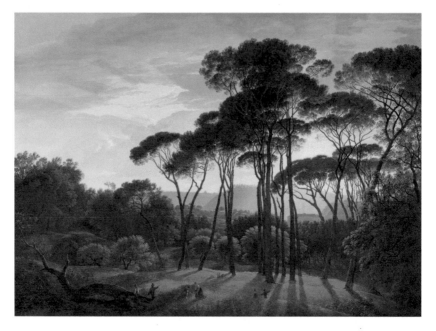

Italian landscape with pines (1807) - Hendrik Voogd

This painting is not a Dutch landscape, but an Italian landscape painted by a Dutch artist, Hendrik Voogd (1768 - 1839). In 1788, he received an endowment to study art in Rome.

During his stay in Rome he became part of a group of landscape painters who were particularly interested in light effects. This painting shows his magnificent technique. The brushstrokes are nearly invisible, the light is cool but radiant and the trees are represented in microscopic detail. Voogd spent the rest of his life in Italy, but he is still considered a Dutch painter.

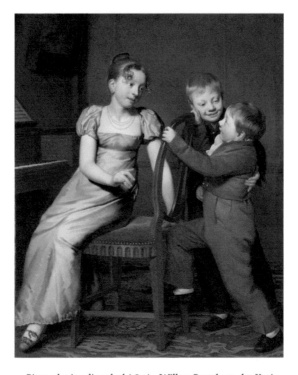

Piano playing disturbed (1813) - Willem Bartel van der Kooi

A girl in a blue dress tries to play the piano but is disturbed by her younger brother. This scene depicted by Willem Bartel van der Kooi (1768 - 1836) looks informal but is very well composed. The children form a triangle in the middle of the composition. The folds and shadows in the girl's dress are meticulously painted. The softness of the cushion on the chair and the fabric of the children's clothes is almost tangible. Their faces are lively and realistic.

High society will do everything to show its wealth in portraits. The painter Jan Adam Kruseman (1804 - 1862) was very popular as a portraitist of the well-to-do.

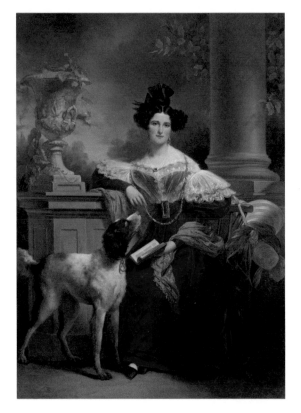

Portrait of Alida Christina Assink (1833) - Jan Adam Kruseman

The lady portrayed here is the 23-year old Alida Christina Assink. Her hoop dress has puffed sleeves and she wears a 'canezou', a kind of transparent jacket. A belt with a big buckle suggests a slim waist.

To give the portrait some international allure, elements from English portraiture have been added: the hunting-dog, the marble vase and the column to her right. The setting is pastoral and dreamy.

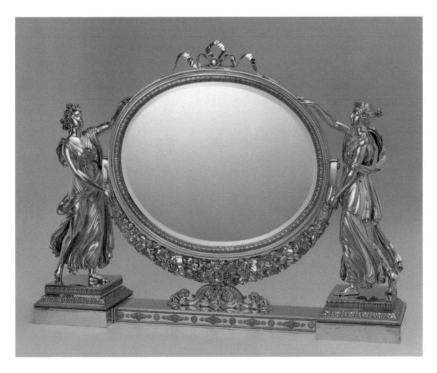

Mirror (1828-1829) - Joseph-Germain Dutalis and Louis Royer

This mirror is an example of the 'Empire' style. Elegant, symmetric and decorated with classical elements like flowers and swans. Two nymphs hold the mirror upright. One of them has flowers in her hair, which symbolizes 'day'. The other has her hair tied up as a symbol of 'night'. They represent the two moments a woman sits in front of the mirror to do her hair and make-up, the morning and the evening. The clothes of the nymphs flap as if moved by wind.

The mirror of gilded silver was part of a set of toiletries, a gift from King Willem I for his daughter Marianne who was to marry Prince Albert of Prussia. By giving such an exquisite object the King could show the rest of Europe his wealth and ambition. Only really powerful men could afford such a present. Funnily enough, objects like these were not in use for a long time but exhibited as art works after a few years.

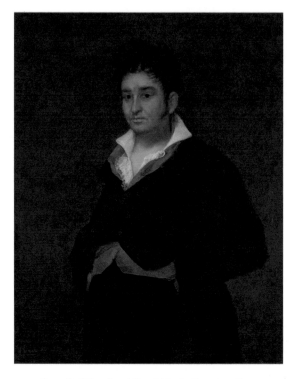

Portrait of Don Ramó Satué (1823) - Francisco Goya

Don Ramón Satué was a Spanish judge who fiercely opposed the occupation of Spain by the troops of Napoleon. After the French occupation he was appointed judge at the Supreme Court of Spain.

Although he is a man with a high public position, in this painting he is informal, pensive and not at all impeccably dressed. He even has his hands in his pockets. The combination of a dark suit against a neutral background makes way for one beautiful accent in the composition, the red of his vest.

The Spanish painter Francisco de Goya y Lucientes (1746 - 1828) is known for his portraits of members of the Spanish Court and his surrealistic drawings. Because of the informal posture and the open shirt of his model this painting is believed to be a friendship portrait.

 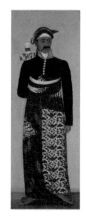 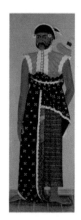 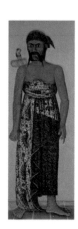

Court officials from Java (circa 1820-1870), by anonymous

The Dutch East Indies, nowadays known as Indonesia, were a Dutch colony until 1949, and one of the most profitable parts of the Kingdom with a perfect climate to grow spices. The Dutch and East Indian cultures had a big influence on each other. In these four paintings, out of a series of five, we see prototypes of court officials from Java. It is believed that the painter was not a Western artist. The descent, rank and status of these Javanese cour officials is shown by their garments with batik motifs and their weapons.

The third man wears a jacket in western style. It is very rare to see Javanese portrayed like this. Normally, the Dutch would depict them as servile subjects, dangerous opponents or unspoilt savages.

The man on the far right is a body guard. His clothes show the wings of a 'garuda', half man, half eagle. His garment is somewhat shorter, so he can spring to action if needed.

The second man is a 'mantri', an administrator. His garments shows feathers of chickens and peacocks. The black band around the hilt of his sword ('kris') shows his high status.

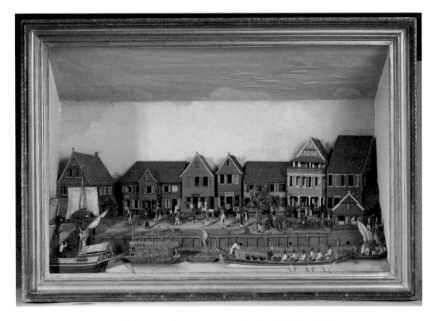

Diorama of the waterfront in Paramaribo (1820) - Gerrit Schouten

Suriname was a Dutch colony until 1975. It was traded with the English for the island of Manhattan in 1667. Because of the fertile soil in this country the Dutch started a lot of plantations and built a city, Paramaribo.

In this wooden diorama, we see a detailed depiction of a particular part of Paramaribo the waterfront. The waterfront along the Suriname River was the vital hub of Surinamese trade.

The artist Gerrit Schouten (1779 - 1839) made an exact copy of the street with its houses, including house numbers, drainpipes and different types of ships. People of various ethnic origins walk about. Take a closer look to find the vicar with his green parasol and the white merchant with his slave carrying his goods.

At the left we see a merchantman sailing out. The boat next to it carries goods to the plantations. The man who commissioned the diorama, British merchant William Leckie, lived in the green house.

A year after the diorama was made, in 1821, the waterfront was

completely destroyed by fire. One night, four hundred houses and 800 hundred warehouses were lost, as well as churches, a theatre and a weighing-house.

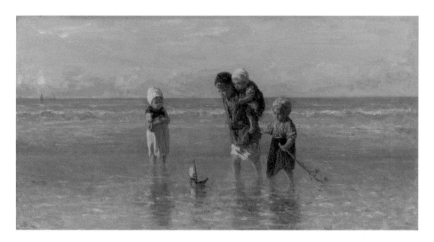

Children of the sea (1872) - Jozef Israëls

What looks like a group of children playing in the water is not a happy painting. The children are not on a day out, they are from a poor fisherman's family. They don't play and they don't smile. The elder boy carries his youngest sister, a foreboding of his future responsibilities. The paper boat will be a real fisherman's boat later. The girl on the left looks like a fisherwoman waiting for her husband to return from the dangerous sea.

Paintings by Jozef Israëls (1824 - 1891) were very popular at the time. He created his paintings in the style of the Hague School representing ordinary farmers and fishermen, depicted in broad brushstrokes.

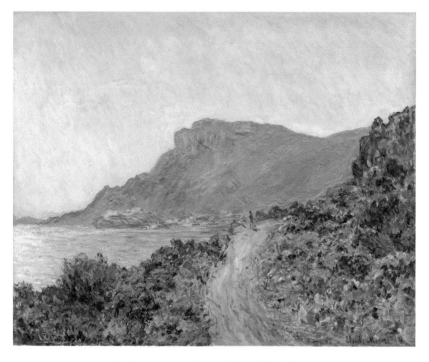

La Corniche near Monaco (1884) - Claude Monet

Impressionist painters worked with swift and loose brushstrokes to catch the first impression of an object or a landscape. Claude Monet (1840 - 1926) is one of the founding fathers of this new style. He had an important influence on Dutch painters such as Breitner and Willem Witsen. The painting is one of Monet's first works ever to be shown in public in the Netherlands. The warmth and dreamy character are unmistakably his.

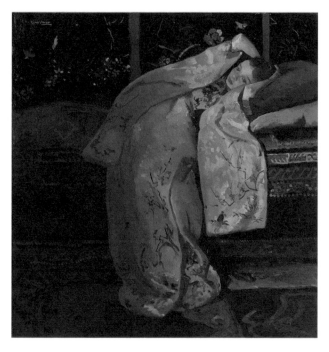

Girl in a white Kimono (1894) - Georg Hendrik Breitner

The painter George Hendrik Breitner (1857 - 1923), made a series of twelve paintings of a girl in a kimono around the year 1894, only one of which is in the Rijksmuseum. Like many artists at the end of the 19th century, Breitner was inspired by Japanese art. Not only the outfit of the girl is Japanese, but also the folding screen in the back and the decoration of the cushions.

From a technical point of view this is also a Japanese painting. Not so much the person in the painting is important, but the composition that consists of flat surfaces and clear colors. The cushions, kimono and background form a unity.

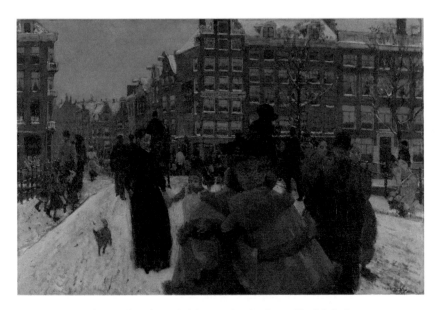

Bridge over Singel, near Paleisstraat (1896) - George Hendrik Breitner

In this painting we see people crossing a bridge in Amsterdam near Dam Square. A well-dressed lady in the middle walks right towards us. For a lot of his paintings, George Breitner made photos as a preparation. This was criticized by traditional art lovers, but Breitner simply stated that with this mechanical aid he could focus better on details while painting.

The composition, however, is very much like a photo: very direct, sharply cut and almost like a snapshot. The paint has been applied to the canvas with a light touch.

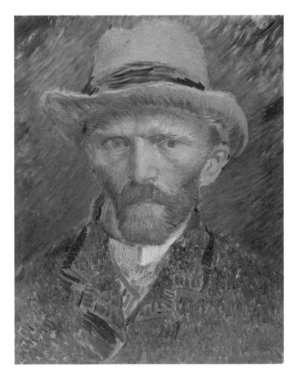

Self-portrait in a felt hat (1887) - Vincent van Gogh

This is one of the many self-portraits Van Gogh produced. It shows the style which made him famous: the expressive brush strokes and the daring color combinations. Even though Van Gogh worked quickly, he always knew exactly what he was doing.

The different elements like the background, the jacket and the face are painted in different 'rhythms': there is a variation of long and short strokes of the brush next to broad and small stripes, dots and lines. His eyes are of a fiery green, his ginger beard a mixture of many color tones.

Together with Rembrandt, Vincent van Gogh (1853 - 1890) is the most famous painter of the Netherlands. After pursuing different careers as an art merchant and a pastor, Van Gogh decided to devote his life entirely to painting at the age of twenty-seven. He lived and worked in the Netherlands, England, Belgium and France. As an artist, he was

almost entirely self-taught, seeking inspiration from old masters and colleagues.

Van Gogh loved to read about art and was an avid museum goer. In 1885 he paid a visit to the Rijksmuseum, where he spent hours in front of *The Jewish Bride*. In letters to his friends and family he wrote about his love for this work by Rembrandt:

> 'Could you believe that I would give ten years of my life to spend two weeks alone with this painting?'

The Rijksmuseum only has this one self-portrait by Vincent van Gogh in its collection.

For more information on his life and works, please see the Van Gogh Museum guide in this series. The Van Gogh museum is the world's authority on Van Gogh and is just a two-minute walk from the Rijksmuseum.

20TH-CENTURY ART

Although most people know the Rijksmuseum as the museum with *The Night Watch* its task is much bigger than just preserving this world famous masterwork. The official title of the museum is 'National Museum of History and Art'. The Rijksmuseum keeps track of current developments and shows contemporary objects alongside the Dutch Masters. The museum has an impressive collection of modern art on the top floors. Objects range from paintings and photographs to models, furniture and typographic designs.

Due to copyright restrictions it is unfortunately not possible to show the most recent acquisitions. In addition, many art works of the 20th century are on loan from other museums. Therefore, this chapter is limited compared to the rest of this guide.

Since the Rijksmuseum is also guardian of Dutch history, objects like planes and guns are very common to find in this museum, especially if they are also interesting from a designer's point of view. The biplane 'Bantam' was built in 1917. (It cannot be reproduced here due to copyright issues). Its purpose was to fight on the British side during World War I. The designer is the Dutch engineer Frits Koolhoven (1886 - 1946), who worked for the British Aerial Transport

Company. The 'Bantam' is a one-seat plane made of wood and was tested with different engines, making a huge impression at various aerial shows

The 19th and 20th century are the ages of the technical revolutions, in a world that was still steeped in age-old political relations.

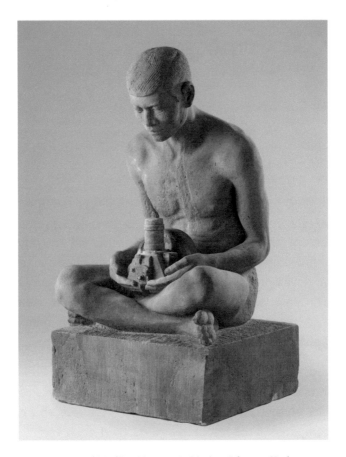

Man and Machine (circa 1913) - Marinus Johannes Hack

This statue made by J.M. Hack (1871 - 1939) shows a man from the Dutch East Indies, nowadays known as Indonesia. It was made as decoration for a firm producing machinery for colonial companies. The man is portrayed as a native working with his hands. The machine he holds symbolizes the idea of the good influence of Dutch

technical standards and welfare on the lives of the original inhabitants of the Indies.

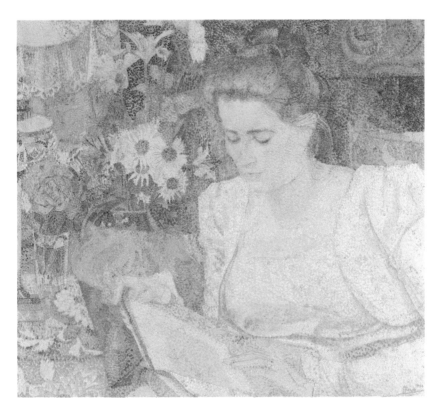

Portrait of Marie Jeannette de Lange (1900) - Jan Toorop

The lady reading in this colorful painting is the chairwoman of the 'Association for the Improvement of Women's Clothing', Marie Jeanette de Lange. She is portrayed in the clothes she promoted, loose-fitting and comfortable.

The painter Jan Toorop (1858 - 1928) made this portrait in a pointillist style. The picture is a true feast of colors, and never ceases to amaze. Its colors are light and vibrant, the brushstrokes are mere dots and dashes.

ASIAN ART

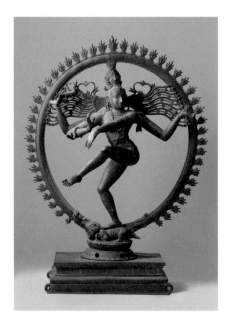

Shiva Nataraja (12th century), India, Tamil Nadu

The Rijksmuseum has an exquisite collection of Asian art. To house this collection, a special pavilion was built in the garden. From the

outside this pavilion looks like a closed structure, but inside it is open space, tranquil and light.

Floating like a flower in a pond of the Rijksmuseum garden, this section is one of the gems. This part of the collection does not have a storyline or central theme. Top works are shown from different countries and periods.

The god Shiva is both creator and destroyer of the world. In this bronze statue he is shown in his incarnation as Nataraja, the king of dance. Creation is symbolized by the drum in his right back hand. Vibrations are new life. Purifying destruction is shown by the fire in his left back hand. By the combination of these elements, Shiva shows perfect balance. He dances in a controlled way and superior posture, surrounded by a circle of cosmic fire, while his right foot crushes a dwarf, symbol of ignorance.

On feast days, richly decorated bronze figures of Hindu gods were carried in procession. Carrying poles would be inserted through the rings on the base.

For Shiva's followers, watching the god dance is a blessing that gives deeper insights that can lead to salvation. He is the symbol of constant change, the universe in movement.

Religious objects like these have more than just artistic value. They form a link between heaven and earth. Therefore, works like these were manufactured according to strict protocol. In Western societies, saints and relics played a similar role, being mediators between the human and divine worlds. For every aspect of daily life, there is a deity you can address.

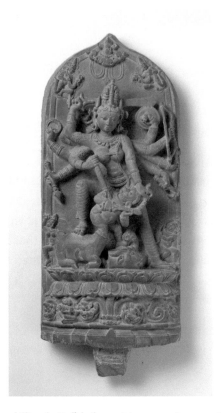

Durga killing the Buffalo demon (circa 1000-circa 1100 A.D.)
Bangladesh

The goddess Durga kills the demon Mahisha in a magnificent display of movement and force. In her ten hands she holds various weapons. She stabs the demon that comes out of a decapitated bull. If you look closely, you will notice that the lion at her feet helps her fight.

The whole scene is set on a lotus flower. This flower grows out of mud through troubled water towards the sunlight and is therefore a symbol of enlightenment. Demons and gods are in constant battle in Hinduism. The evil demons destroy balance, after which the gods have to restore it again.

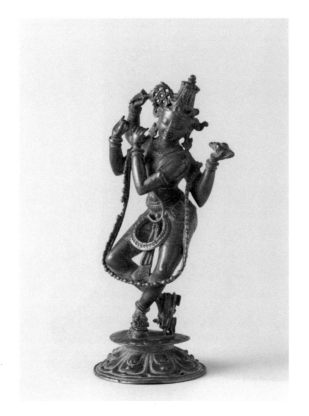

Krishna playing the flute (circa 1500-circa 1700), India, Orissa

Krishna is one of the ten appearances or *avatars* of Vishnu, the guardian of cosmic balance. Born and raised a farmer's son, he is known for his beauty and his flute playing. In this brass sculpture he is shown dancing and playing, with garlands of flowers hanging from his shoulders. The chakra and shell in his back hands identify him as Krishna. With his beauty and talent, he lures women to leave their sleeping husbands at night and dance with him in the forest. He is therefore known as the symbol of total surrender to god and of unification with him. Like Durga above, the foot of this sculpture is a lotus flower, the symbol of enlightenment.

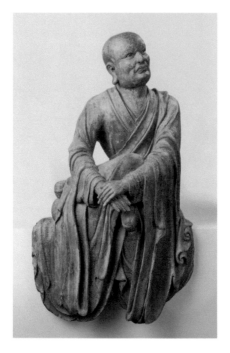

A lohan (circa 1200-circa 1400), China

A lohan is a follower of Buddha who has accomplished spiritual perfection. He guards the Buddhist law until the Buddha himself returns to earth. A lohan lives as a hermit in the mountains and has supernatural powers. His big earlobes, symbols of knowledge, identify him as a monk. Although he sits comfortably, his torso and face are turned upwards because he listens intently to the recitation of a 'sutra', a text of the Buddhist law. The eyes in this wooden sculpture are made of glass which makes them shimmer and emphasize his intelligence.

In the Asian pavilion of the Rijksmuseum this lohan is located in front of the stairs leading to the ground floor. You cannot miss him while visiting the pavilion. He will look right at you.

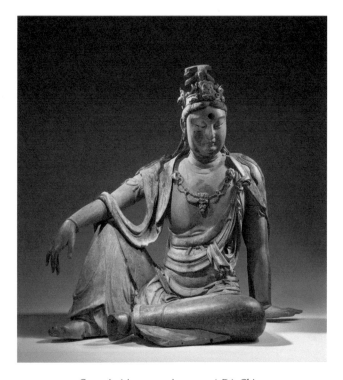

Guanyin (circa 1100-circa 1200 A.D.), China

The Buddhist deity Guanyin is a savior of people in distress. According to legend he was once found in this posture, meditating on the reflection of the moonlight in the water. That is why the god is looking down. The moon on the surface of the water is a symbol of transience and illusion.

His pose is known as 'the relaxation of the Great King', with his left leg on the floor and his right leg supporting his arm. Under his tiara his braids hang loosely on his shoulders. His whole demeanor radiates tranquillity and concentration.

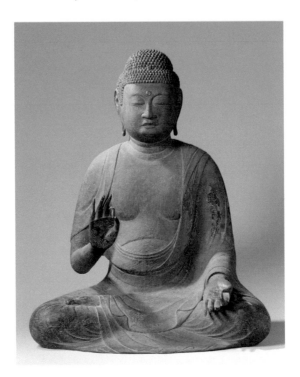

Buddha Amida (circa 1125-circa 1175), Japan

The Buddha Amida is a Buddha for simple believers. No complex rituals are needed to show you the way to the Truth. Simply but sincerely believing in Amida and invoking him will open the gates of Paradise. It is a direct and emotional connection to the Buddha. In this sculpture we recognize him by the three wrinkles around his neck, the big earlobes and the bulge on his head. He holds his right hand, with membranes between the fingers, in the teaching position. Thumb and index finger touch each other at the tips.

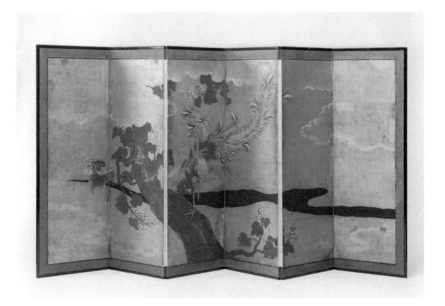

Folding screen (circa 1750-1850)

This folding screen forms an ensemble with a second screen. Like in Japanese scripture we have to read from right to left. The screens symbolize the transition from winter to spring. Folding screens were only used during the season which they represent.

A mythological hoo bird is depicted on the left screen. Together with the paulownia tree it is a symbol of sound statesmanship, and a popular subject for works of art of the ruling Japanese elite in the Edo period (1600-1868).

At that time Japan was largely cut off from the world; the ships depicted in the right screen come from two of the very few countries that had access to Japan, namely China and the Netherlands.

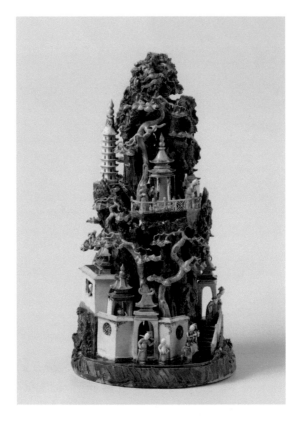

Miniature Garden (circa 1700-circa 1724)

Gardens can even be found inside the Rijksmuseum..! This beautiful porcelain rock with garden is one of the 'must sees' of the Asian collection. The object seems to have been made at the beginning of the 18th century, during the late Kangxi-period (1662 - 1722).

A rock is shown with a pathway leading to the top. Alongside the path there are garden houses and trees. Were this real, everywhere you would walk you could take a seat to enjoy the scenery. The rock has been put together like a jigsaw puzzle. The refinement in details is breathtaking. Take a close look at the people strolling about, the trees and the pagodas. It is almost like reading a storybook. The garden represents the universe.

This miniature rock was perhaps a table decoration of a so-called

'literate'. Literates were administrators who were confined to a life of writing and copying texts at their desks. This miniature universe would inspire them to work or write a poem or maybe even to paint.

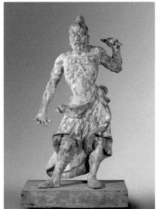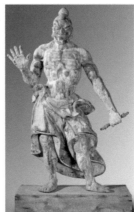

Temple guards (14th century), Japan

These impressive creatures are temple guards from Japan. Every Buddhist temple has two figures like these at the entrance. They are big muscular men with a fierce look in their eyes.

Their task is to protect the temple from evil. With their right hand they keep off any unwanted visitors. In their left hand they keep a diamond 'vajra', with which they can crush ignorance. Notice how one of the guards has his mouth open and the other one closed. They symbolize the open beginning ('a!') and the closed end ('un!') of their Siddham alphabet. All other sounds and writings, in fact all knowledge, lies between those two sounds. He who enters the temple will acquire this knowledge. The statues are made of wood.

We can still see the traces of the paint of their original decoration. Take a look inside them, you will see the original beams on which the

statues were placed. Although the men look quite impressive, they are mild-tempered and stand for all good in the world.

In Japanese culture they are well-loved. On special holidays, children crawl between their legs to gain a bit of their power. To plea for the sick and weak, people attach written messages to the temple gate protected by these guards.

SPECIAL COLLECTIONS

The Special Collections section is the 'surprise act' of the Rijksmuseum. Unlike the top floors, where the art works are arranged according to century, the Special Collections galleries are like a big candy box of art with small-scale exhibitions in every room. Each room is a treat, and the way the objects are displayed is superb.

You will find ships' models, porcelain tea sets, engraved glass and silver, but also magic lanterns that still work, a silent disco in the music section and much, much more. You will feel like a child in a toy store.

A few highlights of the Special Collection are shown below.

The Rijksmuseum has a large collection of slides that were used with the magic lantern. Just like nowadays watching a Netflix episode together, people would visit each other to look at the slides and tell each other the stories that go with them. Not only was this is a serious pastime with educational purposes, there was also room for fun. Scary faces, midgets and weird animals were shown.

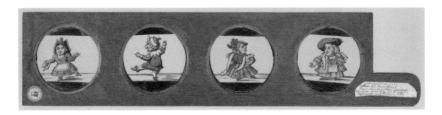

Four midgets (circa 1710-circa 1790), by anonymous

The Netherlands have a long and impressive maritime history. The world power of the 17th century was partly founded on a worldwide network of colonies and coast fortifications. By 1650, the Dutch had the largest fleet in the world and Amsterdam was known to have the world's biggest harbor. The old trade of building wooden ships is still preserved in the ships models section.

Besides models of complete ships you will find compasses, canons and ships decorations. This model of a 19th- century submarine is on display as well.

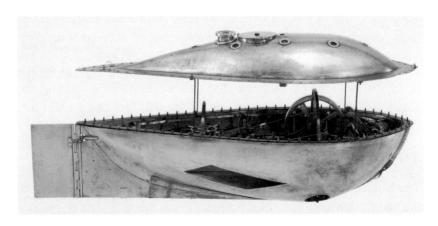

Model of a submarine (1835-1840) - Antoine Lipkens

LOCATION AND TICKETS

For up-to-date information on opening hours, ticket prices and directions, please visit the Rijksmuseum website:

www.rijksmuseum.nl

The Rijksmuseum is located at Museumplein, the cultural heart of Amsterdam where you will find three internationally renowned museums and one of the most beautiful concert halls in the world, the Concertgebouw, all within a 3-minute walking range.

The Van Gogh Museum has the world's largest collection of Van Gogh's paintings and drawings. Photo Amsterdam Publishers.

The Stedelijk Museum is the most important museum in the
Netherlands for modern and contemporary art. Copyright Creative
Commons.

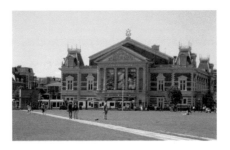

The Concertgebouw, from Museumplein. It has the world's finest
acoustics for classical music. Copyright Creative Commons,
Supercarwaar.

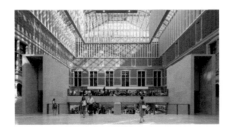

Atrium of the Rijksmuseum. Architect: Cruz y Ortiz. Picture by
Wikimedia Commons.

FURTHER READING

Should you wish to read some more Amsterdam Museum Guides, the following publications are available:

The Van Gogh Museum Amsterdam: Highlights of the Collection.
A lavishly illustrated museum guide containing the most important highlights of the Van Gogh Museum in Amsterdam which houses the

largest collection of Vincent van Gogh's paintings, drawings, letters and prints in the world.

The Anne Frank House Amsterdam - Anne's Secret Annex turned into Museum. A museum you should definitely see when you are in Amsterdam. It was the hiding place during the Second World War of Anne Frank trying to escape deportation by the Nazis.

The Hermitage Amsterdam. Highlights from the Hermitage

Museum St Petersburg. The Hermitage Amsterdam is the only European satellite of the famous Hermitage in St Petersburg in Russia.

Things To Do In Amsterdam: Museums is the all-in-one digital set containing all four Amsterdam Museum Guides.

COLOPHON

Title: Rijksmuseum Amsterdam. Highlights of the Collection

Author: Marko Kassenaar

Editors: Liesbeth Heenk, Malin Lönnberg

Series: Amsterdam Museum Guides

Publisher: Amsterdam Publishers, The Netherlands

info@amsterdampublishers.com

Made in the USA
Columbia, SC
02 August 2024